The complete graphic work of PAUL NASH

The complete graphic work of **PAUL NASH**

Alexander Postan

Secker & Warburg
London

First published in England 1973 by
Martin Secker & Warburg Limited
14 Carlisle Street, London W1V 6NN

Copyright © by Alexander Postan 1973

SBN: 436 37815 9

Designed by Graham Johnson/Lund Humphries
Printed in Great Britain by Lund Humphries

Contents

Acknowledgements

The author and publishers would like to thank the following
for their help, encouragement and permission to reproduce photographs:

The Paul Nash Trustees
Mrs Anstice Shaw
Robin Langdon-Davies Esq
George Wingfield Digby Esq
Philip James Esq

Joseph Darracott Esq
Hamet Gallery Limited
Miss S. L. Wilkinson
The Imperial War Museum
The Victoria and Albert Museum
The Tate Gallery
P. & D. Colnaghi & Co. Ltd

Introduction

It is not the author's intention to elaborate on Nash's vision or growth as a complete artist. This essay is intended as an additional note to the list of prints. Similarities, where they occur, to Nash's paintings and watercolours will be referred to, the origins and influences of various images will be discussed and the relative history of these images will be compared between the three basic media of Nash's work.

The story does not begin until quite late in Nash's career. It is surprising that an artist whose early ambition was to become a book illustrator did not produce any work in any illustrator's medium until he was a married war veteran of 28. As a young man, Nash had made many illustrative drawings heavily influenced by Art Nouveau and pre-Raphaelitism, forces which continued to shape Nash's style until the outbreak of the First World War. It was the success of a small exhibition of drawings and watercolours at the Goupil Gallery, London in 1917, made while Nash was at the Front with the Artists' Rifles, that first set Nash to lithography – a technique requiring no new skill on the part of the artist as he had learnt to control a pencil or crayon with a fluency that he was never to achieve with oils. It is reasonable to assume that the young country lad who dreamt of life as a book illustrator had taken no practical steps to acquire the skills of etching, engraving, mezzotint, or woodcut.

The exhibition at the Goupil Gallery and its commercial success provided the incentive to produce images in the sort of numbers that a print allows, and for his exhibition at the Leicester Galleries in 1918, seven lithographs were included in a total of fifty-six exhibits.[1] These lithographs, L1–L7, can now be seen as his finest prints. At this stage of his life Nash shows an intensity of vision and commitment to a message that was never matched in his later work. These images, although technically crude by the standards of his late work, in particular his delicate and restrained watercolours, was to British painting what Owen and Sassoon were to British poetry. Nash chose subjects to draw

[1] See Appendix I.

and paint that were considered startling: the mud and churned earth that form the subject of *The Crater, Hill 60*,[2] far from exciting laughter or ridicule, conveyed a powerful and effective view of a new form of hell to his audience in London. *Void* and *Rain, Lake Zillebecke* and *German Double Pill-Box, Gheluvelt* (L2, L3, L5) are landscapes that, by their use of stark monochrome, exaggerate the horror that swallowed a generation. These powerful pictures told a story to their original viewers in a way that our blasé and experienced eyes accept without surprise. These seven lithographs are the carefully worked finished items for which there are many studies and related drawings.

It is after the First World War that Nash's first experiments in woodcut take place. *St Pancras* and *Diseuse* (W1, W2) are but crude essays – even *Tree Group* (W3), charming though it is, cannot claim a place beside the lithographs of the previous year. It is not until the Dymchurch series, *Promenade 1* and *2*, *Sea Wall* and *The Bay* (W8–W10, W27) that we see Nash woodcuts of any real authority. Dymchurch, where Nash lived for four years, was a quiet seaside town on the border of Kent and Sussex. After the near shell-shock, gassing and chest injuries that he had received fighting for King and Country, Dymchurch allowed Nash to recuperate but did not provide a stimulus sufficient to excite anything of the calibre of previous years. Significantly, the most impressive treatments of Dymchurch are the retrospective paintings *Winter Sea*[3] and *Nostalgic Landscape*,[4] both finished in the surrealist mood so well exploited by Nash in the belated British Surrealist Movement of the late thirties. His contribution as a Surrealist grew out of a unique ability to extract the mystery from landscape: the sense of place, always vital to Nash, provided a springboard for an uncontrived surrealism of landscape that culminated with *Raider on the Moors* (L21) and the *Dawn Flowers*.[5]

It is convenient to consider the Dymchurch woodcuts and

[2] See L1. All the war lithographs are closely related in both subject matter and technique to his chalk drawings of the period. The Imperial War Museum possesses the largest collection of Nash's First World War work.

[3] See *Winter Sea*, 1925–37. Oil on canvas. Reproduced as No. 28, *Paul Nash—a Memorial Volume*, Lund Humphries, 1948.

[4] See *Nostalgic Landscape*, 1923–38. Oil on canvas. Reproduced as Plate 19, *Paul Nash*, Penguin Modern Painters Series, Penguin Books, 1944.

[5] See *Dawn Flowers*, 1944, Watercolour. Reproduced No. 111, *Paul Nash – a Memorial Volume*.

lithographs together: on one hand, the woodcuts are concerned with the dynamic interaction of land and sea, while the lithographs are more topographical, but they all share the "sense of place" of the sea-front that was the key to Nash's view of Dymchurch. When a figure is introduced, it is always secondary to the panorama, the billowing of a skirt as a device to suggest a breeze, or to suggest the peacefulness of two people strolling along a deserted sea-wall.

It was at Dymchurch that Nash began a series of woodcuts as book illustrations, on which he worked until 1929. The eight books produced were *Cotswold Characters*, *Places*, *Mister Bosphorus and the Muses*, *Genesis*, *Wagner's Music Drama of The Ring*, *Welchman's Hose*, *Abd-er-Rhaman in Paradise*, and *A Song about Tsar Ivan Vasilyevitch* . . . They form a fascinating progression of woodcuts, demonstrating a coherent development of style. *Cotswold Characters*, the first of the group, although a delightful example of English book design, is the weakest book of his woodcuts. Never able to imbue figure studies with any vestige of the assurance so apparent in the "placescapes", Nash was bound to fail in this short collection of vignettes of English countryfolk. There can be no better illustrations of his real abilities than the comparison of *Places* and *Cotswold Characters*, worked on simultaneously and completed within a year of each other. The quality of *Places* sets the standard by which all Nash's illustrative work must be judged: marred only by typographical shortcomings – an execrable title page and arch "arty-crafty" reproduction script – the places themselves are full of the mood evoked by the Dymchurch series. They are places that the young war invalid must have seen as a form of heaven after the muddy hell of the Ypres Salient and the Menin Road.

Mister Bosphorus and the Muses followed *Places* and although the overall quality is not exceptional, there are a number of very fine woodcuts used as illustrations, notably *Exit Northern Muse* (W31), *Poor Northern Muse* (W29) and *Road Over a Moor* (W35). The latter is reminiscent of Wyndham Lewis and Ravilious, and is one of the few convincing Nash studies of the human figure, although the landscape is of paramount importance to the overall effect. The diagonal rain is comparable to the skies of the war lithographs. The diagonal is an important trademark of vorticist painting, in particular of Nevinson and Roberts, two other British artists of the same generation whose

war work followed experiments in abstract painting.

Of this group of young war artists, only Nash went on to experiment with later forms of abstraction. Lewis, Roberts and Nevinson never regained their will to experiment in the manner that made the vorticist movement quite so vital. Nevinson tailed off into appalling mediocrity, Roberts devoted the next fifty-five years to a stylized "social realism", that at its best equals the work of Léger, while Lewis, a gorilla amongst rhesus monkeys, never matched his swirling years at the centre of the Vortex. Nash, never a revolutionary, is almost unique among British artists of this century: as a young man, he burst out with a fresh and powerful vision in the form of his war paintings, but he never lapsed into the dreary wandering that was the fate of all but a handful of British painters.

It was ten years after the Vortex's arrest that Nash made his first abstract statement in *Genesis*, where abstract subjects had to be treated visually, as in *The Division of Light from Darkness* (W44), *The Firmament* (W45) and *Contemplation* (W53). It is this acceptance of abstraction and its subsequent use that is the important quality of *Genesis*. In addition to this enlargement of the illustrator's vocabulary, the overall quality of design in *Genesis* is of the highest order. In particular, the use of Rudolf Koch's Neuland typeface is an early and successful application of this now well-known design.

In comparison with the number of woodcuts used in illustration, Nash made few woodcuts for their own sake, although those that exist are exceptional. After *Promenade 2* (W9) and *Dyke by the Road* (W25), convincing and accomplished examples of a more familiar side of the artist's work, he makes a direct abstract statement with *Abstract No. 1* (W56). The existence of two editions, the second on patterned paper, indicates that he was not happy with the finished state of this woodcut, although it is arguably one of his finest, and entirely successful to contemporary eyes. *Abstract No. 1* is considerably earlier than the bulk of Nash's abstract work, which reached its height in the Unit 1[6]

[6] "Unit 1" was the loose association of artists exhibiting with the Mayor Gallery, who for a short while, under the leadership of Paul Nash, took a "political stand" in the manner of the great Paris pamphleteers of ten years earlier. The artists were Paul Nash, Henry Moore, Barbara Hepworth, Ben Nicholson, Edward Burra, Edward Wardsworth, John Armstrong, and John Bigge. See *Unit I*, Cassell, 1933.

framework of the mid-thirties, and indeed this antedating is a feature of the non-illustrative woodcuts.

 Abstract No. 1, *Coronilla 1* (W64), *Design of Arches* (W74) and *Design of Flowers* (W75) can be considered as the first essays in this neglected aspect of the artist's work. *Coronilla 1* is particularly interesting, as there is a second version of this woodcut (W88), made five years later. A painting almost identical to *Coronilla 1* was painted in 1929.[7] The final book illustrated with woodcuts, *A Song about Tsar Ivan Vasilyevitch . . .*, should be seen as the final stage of Nash's abstract illustrations. As decorations for the book, they do not materially enhance the text, but considered as individual images, they are crisp examples of Nash's constructivism.

 But for *Bookplate for Samuel Courtauld* (W89), the only Surrealist woodcut, Nash produced no further woodcuts. The reasons for this seemingly abrupt dismissal of a medium in which the artist was so proficient are not clear. Possibly the relative lack of financial success of the large exhibition of his woodcuts, held at the Redfern Gallery in 1928, may have dissuaded him from producing further work when so many proofs of earlier prints remained unsold. The effective restriction to monochrome, or at least to flat areas of colour, may have been irksome to Nash when lithography or collotype could have provided a very much more sympathetic reproduction of his drawing and watercolour style. It was in 1930 that his greatest illustrated book was published: *Urne Buriall and The Garden of Cyrus*, with its multitude of complex colour illustrations, must have taken all of Nash's energies and provided a result superior to any he could ever have achieved with woodcut. This book never fulfilled the expectations of its publishers, indeed unsold copies remained on the shelves of many book-dealers for as long as twenty years. It is not surprising, therefore, to see virtually no graphic work being published for its own sake, and only commissioned book jackets or posters were made at this time. It is also significant that the decade from 1930 to 1940 was one of great success, both financial and critical, and one can well understand that his new dealers, Tooths (who did not sell or publish graphics, unlike the Redfern Gallery, their predecessors), were loath to encourage

[7] See *Coronilla*, 1929. Oil on canvas. Reproduced as Plate 57, *Paul Nash – a Memorial Volume*.

their artist to spend time on projects that could be of no interest to themselves.

One of the more fortunate aspects of the pressure for visual propaganda during the Second World War was the enlightened policy of the Ministry of Information, who commissioned posters by contemporary artists. *The Battle of Britain* (L23), *The Raider on the Moors* (L21) and *Moonlight Voyage* (L22) are Nash's fabulous statements made within this context. Fascinated by the "personality" of machines, Nash was able to combine his surrealist imagery with a characterization of war-planes to make a convincing personal view of war. *The Raider on the Moors* and *Moonlight Voyage* were worked up from existing watercolours of the period, and are lasting proof that Nash was one of the few artists of the time whose work maintained a consistent quality of vision and execution throughout his life.

Paul Nash: a chronology

1889 Paul Nash born London, 11 May, eldest son of William Henry Nash, Recorder of Abingdon, and Caroline Maude, daughter of Captain Milbourne Jackson, R.N.

1901–6 Educated at St Paul's School, with short interval at tutorial establishment at Greenwich. Failed to pass Naval entrance. Went to live at Wood Lane House, Iver Heath, Bucks. Became boarder at St Paul's.

1906–9 Left school. Began to attend evening art classes at Bolt Court, Fleet Street.

1910–11 Studied at Slade School, while living at Paultons Square, Chelsea.

1912 Held first one-man exhibition at Carfax Gallery.

1914 Enlisted in ranks in Artists' Rifles, August. Detailed for home service. Married Margaret Theodosia, daughter of Rev. N. Odeh, at St Martin-in-the-Fields, 17 December.

1916 Gazetted and Lieutenant in 3rd Hampshire Regiment.

1917 Posted to 15th Hampshire Regiment for service in Ypres Salient, February. Invalided to London, June. Exhibition *Ypres Salient*, Goupil Gallery, July. As result, seconded to Ministry of Information for special duty as War Artist. Returned to France, November.

1918 Exhibition *Void of War*, Leicester Galleries. Lived first at Chalfont St Peter and later took up residence in Fitzroy Street, London.

1919 Visited Chiltern country. Executed theatrical designs for *Truth about the Russian Ballet* by James Barrie.

1921 Went to live at Dymchurch, Kent, to recuperate from serious illness. Illustrated *Cotswold Characters*, Yale University Press.

1922 First visit to Paris (two or three weeks). Illustrated *Places*, William Heinemann Ltd, London.

1923 Illustrated *Mister Bosphorus and the Muses*, Duckworth, London.

1924 Illustrated *Genesis*, Nonesuch Press, London.

1925 Instructor in Design at Royal College of Art. Spent winter at Cros de Cagnes, near Nice. Visited Florence and Siena. Went to live at The Cottage, Iden, near Rye, Sussex. Illustrated *Wagner's Music Drama of The Ring*, Noel Douglas Ltd, London. Illustrated *Welchman's Hose*, The Fleuron Ltd, London.

1928 Illustrated *Abd-er-Rhaman in Paradise*, Golden Cockerel Press.

1929 Illustrated *A Song about Tsar Ivan Vasilyevitch . . .*, Aquila Press, London.

1930 Death of his father and sale of Iver Heath House. Began abstract and constructive series. Visit to Paris and Toulon. On his return went to live at New House, Rye. Illustrated *Urne Buriall and the Garden of Cyrus* for Cassells.

1931 Visited USA as British Representative on the International Jury for the Carnegie Exhibition at Pittsburgh, September.

1932 First signs of asthmatic condition.

1933 Founded Unit 1 Group. Left Rye. Visited Wiltshire, France, Spain and North Africa.

1934 Went to live on the Ballard at Swanage.

1936 Moved to 3 Eldon Grove, Hampstead. Participated in International Surrealist Exhibition in London.

1938 Visited Gloucestershire.

1939 Moved to 106 Banbury Road, Oxford, on outbreak of war.

1940–45 Commissioned as Artist to Royal Air Force. Later became attached to War Artists' Advisory Committee.

1946 Taken seriously ill in January. Visited Boscombe to recuperate in July, where he died on 11 July. Buried in the churchyard of Langley Parish Church, July 17.

1948 Memorial Concert and opening of Memorial Exhibition, attended by H.M. The Queen, in March, at the Tate Gallery.

Notes on the Catalogue

The prints are listed in chronological order in two categories, lithographs and woodcuts.
Sizes are given in inches, height before width.
Abbreviations as follows:

Gould Fletcher	reference to the list of prints published in the *Print Collector's Quarterly*, July 1928, compiled by John Gould Fletcher.
Graham	reference to *A Note on the Book Illustrations of Paul Nash* by Rigby Graham, Brewhouse Press, Wymondham 1965.
IWM	The Imperial War Museum. (If followed by a number, this refers to the catalogue of paintings, drawings and sculpture of the First World War as published by the Imperial War Museum 1963.)
V & A	The Victoria and Albert Museum. (If followed by a number and a date, this refers to the museum accession number and date of accession.)
TG	Tate Gallery.

The name in the third line of most of the catalogue entries is that of the owner of the print reproduced at the time of publication.

Nash signed his prints with a signature: *Paul Nash 1924*

or with his monogram: (N)

Prints left unsigned at the time of Nash's death and in the possession of the estate trustees in June 1972 are authenticated with an atelier stamp: **PNT**

Nash numbered most of his graphic work himself, and although many of his prints bear misleading and incorrect edition numbers, the author has attempted to define the real edition size. In all cases stage proofs exist or have existed, often signed and inscribed. In view of their rarity and similarity to the issued editions, the author has not defined stage proofs as separate states, as Nash always inscribed any stage proof "1st proof", "3rd proof", etc., thus rendering the identity of any proof that has escaped the inspection of the author clear to any student or owner. Final state proofs outside the edition are common and are invariably inscribed "proof".

Lithographs

L1 The Crater, Hill 60 1917
Lithograph $13\frac{3}{4} \times 17\frac{7}{8}$
The Imperial War Museum
V & A E4791–1960, IWM 1601
Edition of 25 proofs on cream wove. According to the note on the proof in the
collection of the Victoria and Albert Museum erroneously dated as from 1918, Margaret
Nash identifies this print as "The Mine Crater, Hill 60, Ypres Salient".

L2 Void 1918
Lithograph 7×9
The Author
V & A E4790–1960
Edition of 25 proofs, some on blue-grey ingres, the remainder on cream wove.

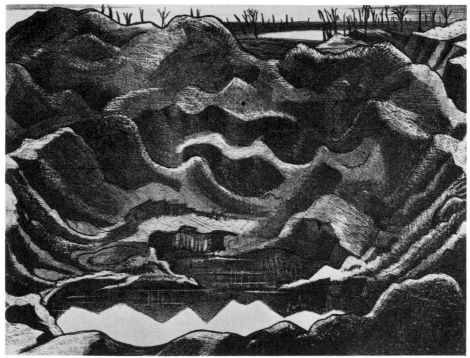

L1

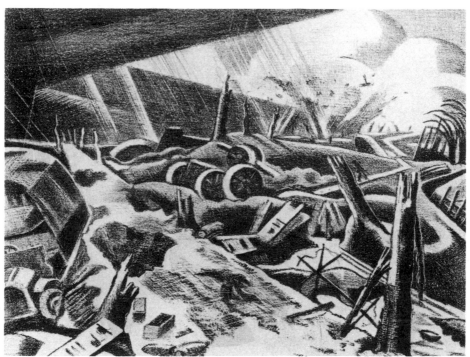

L2

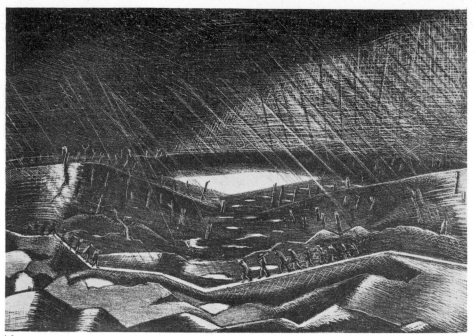

L3

L3 **Rain, Lake Zillebeke 1918**
Lithograph $10\frac{1}{8} \times 14\frac{1}{4}$
The Imperial War Museum
V & A E4792–1960, IWM 1603
Edition of 25 proofs on cream wove with a few proofs on white wove.

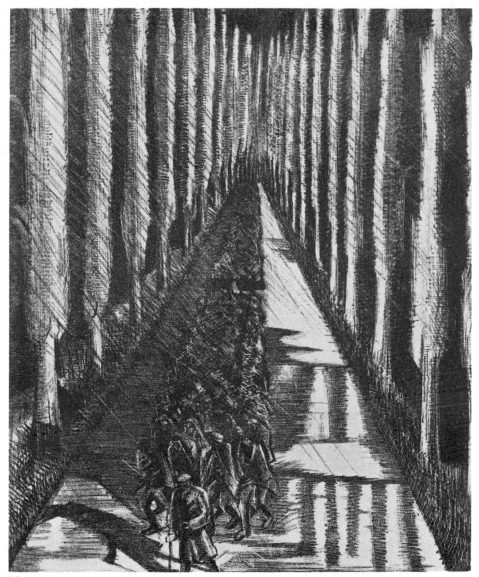

L4

L4 **Marching at Night 1918**
Lithograph $20\frac{1}{4} \times 16\frac{1}{4}$
The Imperial War Museum
V & A E4795–1960, IWM 1605
From edition of 25 signed and numbered proofs on white wove paper.

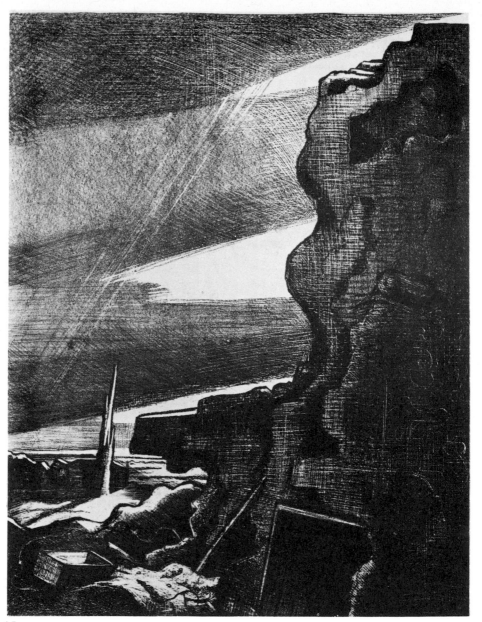

L5

L5 German Double Pill-box, Gheluvelt 1918
Lithograph $17\frac{7}{8} \times 14\frac{1}{8}$
The Imperial War Museum
V & A E4793–1960, IWM 1602
From edition of 25 signed and numbered proofs on white wove paper.

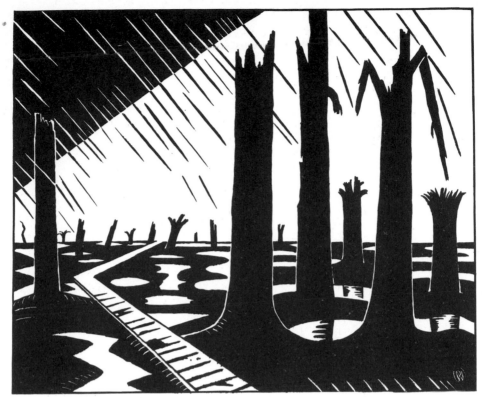

L7

L6 **A Shell Bursting, Passchendaele 1918**
Lithograph $10\frac{1}{4} \times 14\frac{1}{4}$
The Imperial War Museum
V & A E4794–1960, IWM 1604
From edition of 25 signed and numbered proofs on white wove paper.

L7 **Void of War 1918**
Lithograph $14\frac{5}{8} \times 17\frac{1}{8}$
The Victoria and Albert Museum
V & A E4796–1960
Edition of 12 signed and numbered proofs on brown wove paper. This lithograph was used as the design for a poster advertising an exhibition of Nash's work held at the Leicester Galleries, "Void of War", 1918.

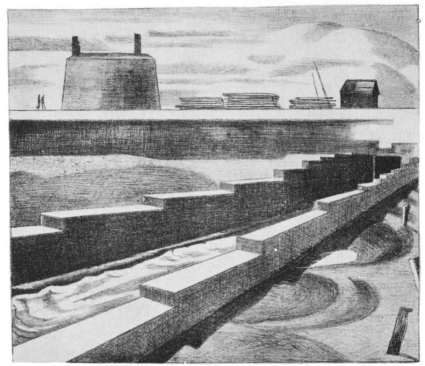

L8

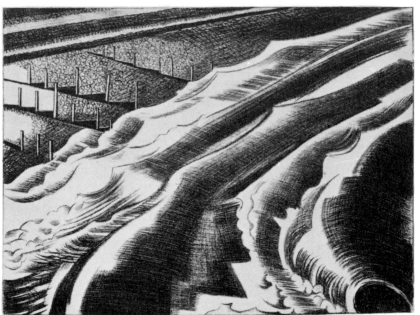

L9

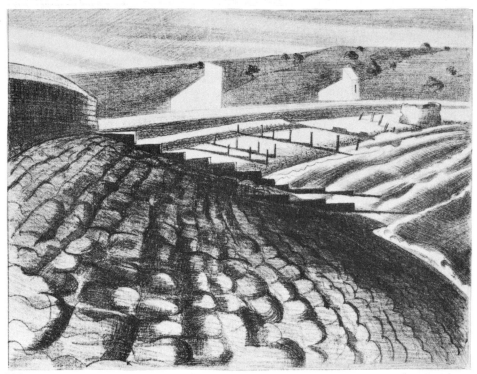

L10

L8 **The Sluice 1920**
Lithograph $14 \times 16\frac{1}{4}$
The Author
V & A E4794–1960
Edition of 30 signed and numbered proofs, 15 proofs on white wove and 15 proofs on yellow wove paper. L8–L11 are all views of Dymchurch, Kent, where Nash lived from 1920 to 1923.

L9 **The Tide, Dymchurch 1920**
Lithograph $12\frac{3}{8} \times 16\frac{5}{8}$
The Author
V & A E4798–1960
Edition of 30 signed and numbered proofs as for L8. This lithograph has alternative titles, "The Bay" and "Tide".

L10 **The Strange Coast 1920**
Lithograph $12\frac{3}{8} \times 16$
The Author
V & A E4799–1960
Edition of 30 signed and numbered proofs as for L8. This lithograph is also known as "Strange Coast, Dymchurch".

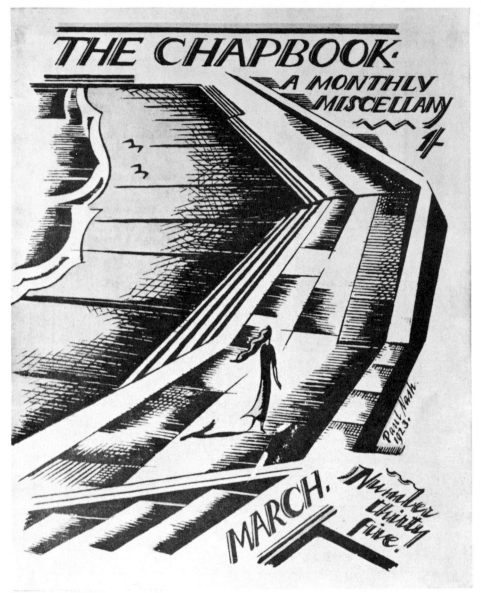

L11

L11 **The Bay 1923**
Colour lithograph $8\frac{3}{8} \times 5\frac{5}{8}$
The Victoria and Albert Museum
V & A E4783–1960
"The Bay" was produced for the cover of *The Chapbook, A Monthly Miscellany*, No. 35,
March 1923. Large edition.

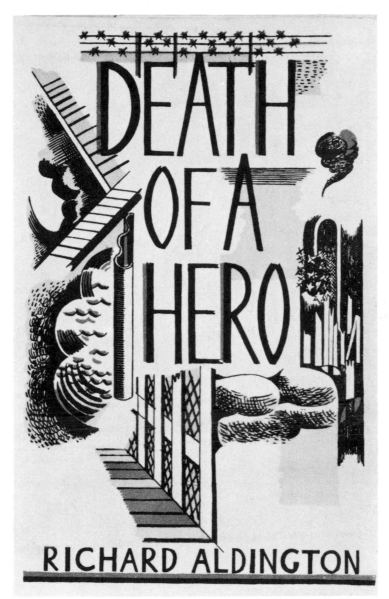

L12

L12 **Death of a Hero 1929**
Colour lithograph $8 \times 4\frac{7}{8}$
The Victoria and Albert Museum
V & A E4782–1960
This lithograph was made for the book jacket of *Death of a Hero* by Richard Aldington,
Chatto & Windus, London 1929. Edition large, but rare in good condition.

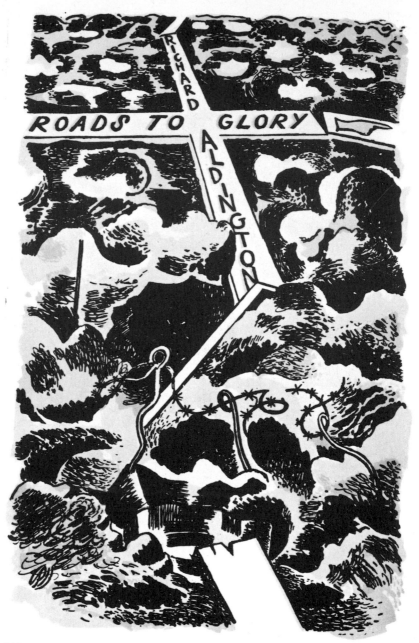

L13

L13 **Roads to Glory 1930**
Colour lithograph $7\frac{5}{8} \times 4\frac{7}{8}$
The Victoria and Albert Museum
V & A E4781–1960
This lithograph was made for the book jacket of *Roads to Glory*, by Richard Aldington,
Chatto & Windus, London 1930. Edition large but rare in good condition.

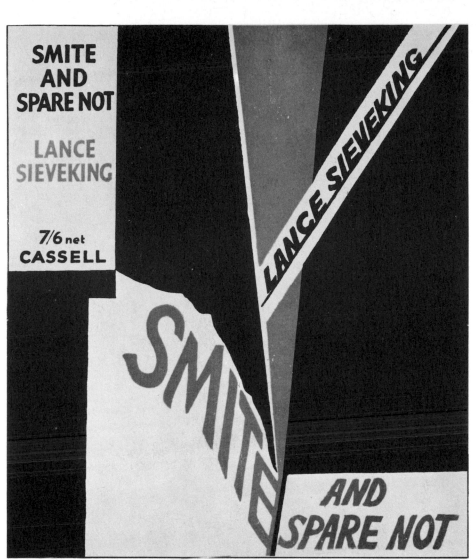

L14

L14 Smite and Spare Not 1933
Colour lithograph $7\frac{1}{4} \times 6\frac{3}{4}$
The Victoria and Albert Museum
V & A E4779–1960
This lithograph was made for the book jacket of *Smite and Spare Not*, by Lance Sieveking,
Cassell & Co., London 1933. Edition large but rare in good condition.

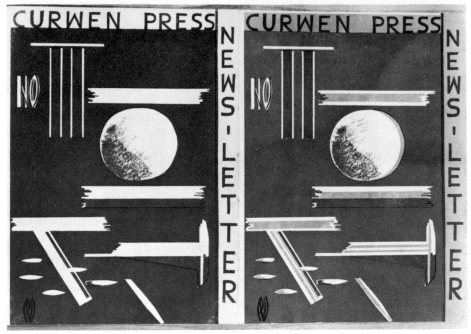

L15

L15 **Curwen Press News Letter No. 11 1935**
Colour lithograph $10\frac{1}{4} \times 17$
The Victoria and Albert Museum
V & A E4777–1960
This lithograph was made for the book jacket of the *Curwen Press News Letter*, No. 11,
1935.

L16 **British Industries Fair 1935**
Colour lithograph $10\frac{3}{8} \times 13$
The Victoria and Albert Museum
V & A E4804–1960
Issued as an advertising leaflet for the British Industries Fair 1935 by the London
Passenger Transport Board. Enormous edition, now very rare.

L17 **Silence in Heaven 1936**
Colour lithograph $7\frac{1}{4} \times 6\frac{3}{4}$
The Victoria and Albert Museum
V & A E4778–1960
This lithograph was made for the book jacket of *Silence in Heaven*, by Lance Sieveking,
Cassell & Co., London 1936. Edition large, now rare.

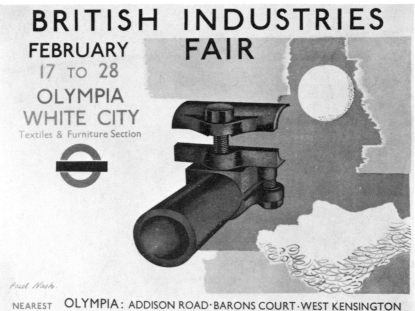

L16

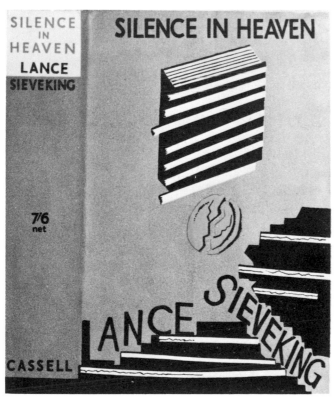

L17

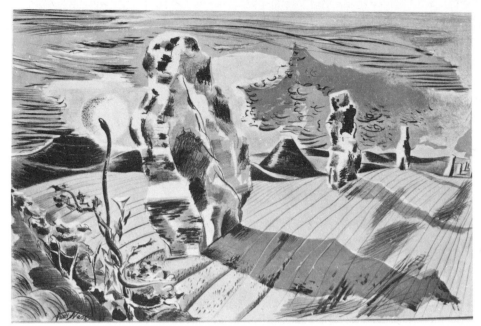

L18

L18 **Landscape of the Megaliths 1937**
Colour lithograph 20 × 30
The Victoria and Albert Museum
V & A E4800–1960
Published as an unlimited edition in 1937 by Contemporary Lithographs Ltd, London.
Approximately 1,000 proofs on white wove paper.

L19 **Come out to Live 1937**
Colour lithograph 40 × 26
The Victoria and Albert Museum
V & A E4802–1960
Poster issued by the London Passenger Transport Board 1937. Unlimited edition on
white wove paper.

L20 **Come in to Play 1937**
Colour lithograph 40 × 26
The Victoria and Albert Museum
V & A E4803–1960
Issued as a poster by the London Passenger Transport Board 1937. Unlimited edition
on white wove paper.

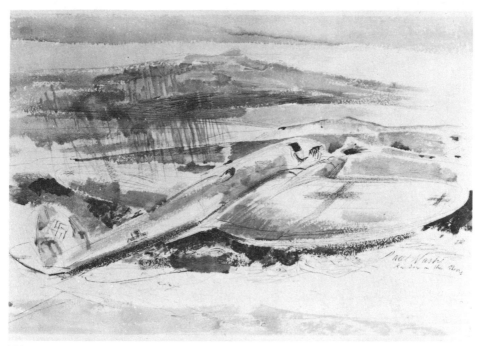

L21

L21 **The Raider on the Moors 1940**
Colour lithograph $15\frac{1}{8} \times 22\frac{1}{4}$
The Victoria and Albert Museum
V & A E4805–1960
Published by the National Gallery, London, for the Ministry of Information 1940.
Large edition on white wove paper.

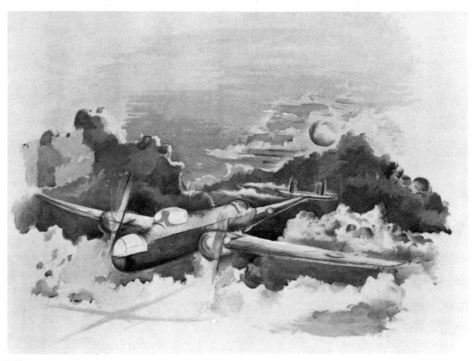

L22

L22 **Moonlight Voyage 1940**
Colour lithograph $16 \times 21\frac{1}{2}$
The Victoria and Albert Museum
V & A E4806–1960
Also titled "Moonlight Voyage, Hampden flying above the Clouds" and "Moonlight Voyage, flying against Germany". Published by the National Gallery, London, for the Ministry of Information 1940. Large edition on buff wove.

L23 **The Battle of Britain 1941**
Colour lithograph 30×40
The Victoria and Albert Museum
V & A E4807–1960
Published by the National Gallery, London, for the Ministry of Information 1941. Large edition on white wove paper.

L24 **Landscape of the Vernal Equinox 1943**
Colour lithograph $29\frac{3}{4} \times 38\frac{1}{8}$
The Victoria and Albert Museum
V & A E5158–1958
Published by the National Gallery, London, 1943. Unlimited edition on white wove paper.

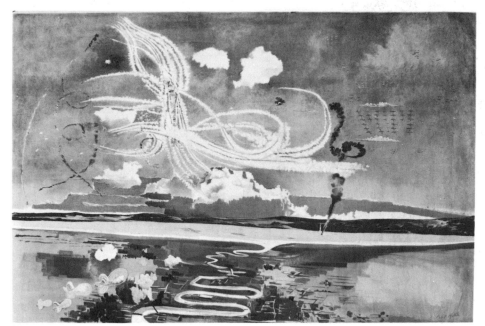

L23

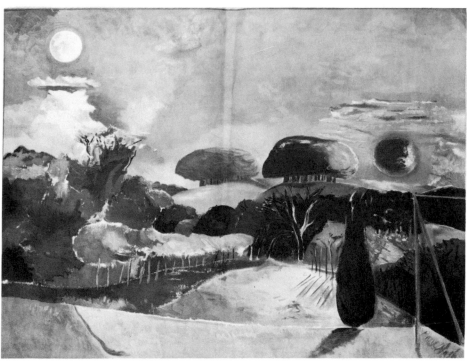

L24

Woodcuts

W1 **St Pancras 1919**
Woodcut $1\frac{1}{4} \times 2\frac{1}{16}$
Gould Fletcher 1
Trial engraving, no edition. According to Gould Fletcher, only one proof was taken.

W2 **Diseuse 1919**
Woodcut $3 \times 2\frac{1}{4}$
Gould Fletcher 2
The Author
A decoration for an invitation card for a private concert of Raymonde Collignon held
at 9 Fitzroy Street, London. No edition, a few proofs on white wove and one on the plain
side of a postcard.

W3 **Tree Group 1919**
Woodcut $3\frac{3}{4} \times 2\frac{3}{4}$
Gould Fletcher 3
P. & D. Colnaghi Ltd
Reproduced in *Voices*, September 1919, Vol. 2, No. 3, and there called "Tree Garden".
Intended to be produced in an edition of 50; in fact a few burnished proofs only, printed
in blue, black and grey on fine japon.

W4 **Snow 1919**
Woodcut $3\frac{1}{16} \times 2\frac{1}{16}$
Gould Fletcher 4
No edition issued, only a few proofs in grey-blue and black. Block destroyed.

W5 **Snow Scene 1919**
Woodcut $3\frac{13}{16} \times 5$
Gould Fletcher 5
Issued as a Christmas card, December 1919. Printed as an edition of 50. Block
destroyed.

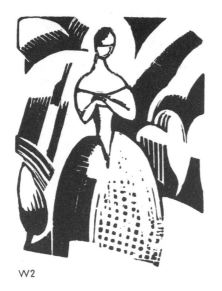

W2

W3

W6 **Elms 1919**
Woodcut $3\frac{13}{16} \times 2\frac{15}{16}$
Gould Fletcher 6
Two states, a few proofs of each state only. Block destroyed. Reproduced in *Art & Letters* Autumn 1919.

W7 **Device 1920**
Woodcut $5\frac{1}{2} \times 4\frac{1}{2}$
Gould Fletcher 7
A few proofs only. For the cover of the Sun Calendar (The Sun Engraving Co.). The Sun Calendar was arranged by Paul Nash and consisted of illustrations by Paul Nash, John Nash and Rupert Lee with poems by William Blake, Walt Whitman, Sacheverell Sitwell, Edith Sitwell, John Drinkwater and W. S. Landor.

W8 **Sea Wall 1920**
Woodcut $3\frac{1}{16} \times 4\frac{3}{8}$
Gould Fletcher 8
A few proofs from a proposed edition of 50. Block destroyed. Reproduced in *The Keepsake*, 1920.

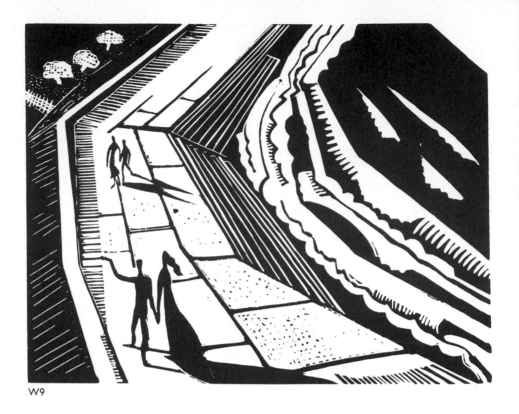

W9

W9 **Promenade No.1 1920**
Woodcut $4\frac{1}{2} \times 5\frac{3}{4}$
P. & D. Colnaghi Ltd
V & A E4774–1960, Gould Fletcher 9
Edition of 25 signed and numbered proofs on white wove paper. The cancelled
woodblock is in the collection of the Victoria and Albert Museum, Accession No.
E4774–1960.

W10 **Promenade No. 2 1920**
Woodcut $4\frac{1}{2} \times 5\frac{3}{4}$
Tate Gallery
TG T1457, Gould Fletcher 10
Issued as an edition of 25, a few numbered but the remainder inscribed "From edition
of 25". Reproduced in *The Apple*, 1921, winter number and also in *Form*, November–
December 1921, Vol. 1, No. 2. A few proofs are erroneously dated 1923.

W11 **The Hearth 1920**
Woodcut $4\frac{1}{16} \times 4\frac{1}{16}$
Gould Fletcher 11
A few proofs used for a Christmas card, 1920. Block destroyed.

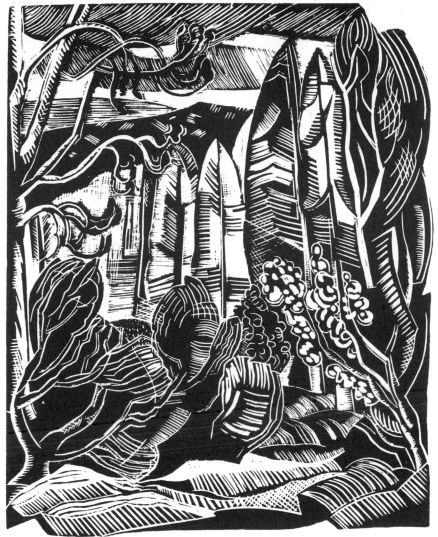

W12

W12 **Winter 1921**
Woodcut $5\frac{1}{16} \times 4\frac{7}{16}$
The Victoria and Albert Museum
Gould Fletcher 12, Graham 5:5
V & A E1460–1922
Two editions: the first as an edition of 50 proofs on white wove or fine japon; the second bound as plate 5 of *Places* by Paul Nash, William Heinemann Ltd, London 1922, in an edition of 55 copies. Reproduced in *The Apple* 1921. The block is in the collection of the Victoria and Albert Museum, Accession No. E5193–1960.

W14

W13 **Dark Lake 1921**
Woodcut 4 × 5
The Victoria and Albert Museum
Gould Fletcher 13, Graham 5:4
V & A E4775–1960
Two editions: the first as an edition of 25 proofs on various papers, mainly white wove, fine japon or blue ingres; the second as an edition of 55 proofs bound as plate 4 of *Places* by Paul Nash, William Heinemann Ltd, London 1922. The cancelled woodblock is in the collection of the Victoria and Albert Museum, Accession No. E5192–1960.

W14 **Thesiger Crowne, the Mason 1921**
Woodcut 3 × 3
The Author
Gould Fletcher 14, Graham 4:1
Illustration to *Cotswold Characters* by John Drinkwater, published by the Yale University Press, 1921. Nine signed and numbered proofs were subsequently issued on white wove paper.

W15 **Simon Rodd, the Fisherman 1921**
Woodcut 3 × 3
The Author
Gould Fletcher 15, Graham 4:2
Illustration to *Cotswold Characters* by John Drinkwater, published by the Yale University Press, 1921. Nine signed and numbered proofs were subsequently issued on white wove paper.

W15

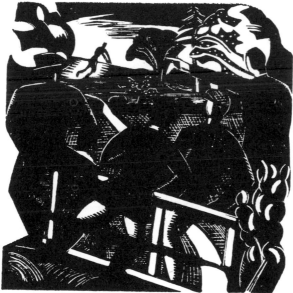

W16

W16 Rufus Clay, the Foreigner 1921
Woodcut 3 × 3
The Author
Gould Fletcher 16, Graham 4:3
Illustration to *Cotswold Characters* by John Drinkwater, published by the Yale
University Press, 1921. Nine signed and numbered proofs were subsequently issued
on white wove paper.

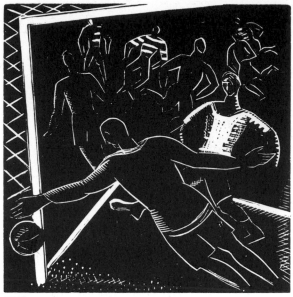

W17

W17 **Pony, the Footballer 1921**
Woodcut 3×3
The Author
Gould Fletcher 17, Graham 4:4
Illustration to *Cotswold Characters* by John Drinkwater, published by the Yale
University Press, 1921. Nine signed and numbered proofs were subsequently issued
on white wove paper.

W18 **Joe Pentifer and Son 1921**
Woodcut 3×3
The Author
Gould Fletcher 18, Graham 4:5
Illustration to *Cotswold Characters* by John Drinkwater, published by the Yale
University Press, 1921. Nine signed and numbered proofs were subsequently issued
on white wove paper.

W19 **Paths into the Wood 1921**
Woodcut $5 \times 4\frac{1}{16}$
The Author
Gould Fletcher 19, Graham 5:6
V & A E4772–1960, E1457–1922
Two editions: the first as an edition of 50 proofs on white wove or fine japon, some
numbered as from an edition of 25 proofs; the second bound as the sixth illustration to
Places by Paul Nash, William Heinemann, London 1922, 55 proofs. The cancelled
woodblock is in the collection of the Victoria and Albert Museum, Accession No.
E5194–1960. Reproduced in *Form*, October 1921, Vol. 1, No. 1.

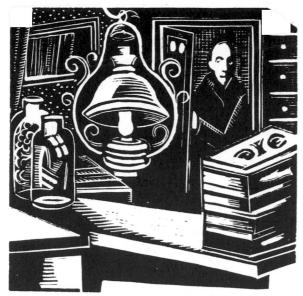

W18

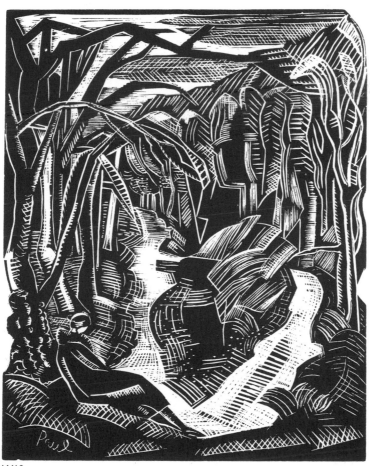

W19

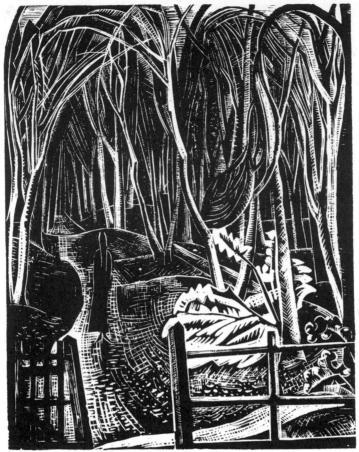

W21

W20 **Design 1922**
Woodcut 3 × 3
Gould Fletcher 20
According to Gould Fletcher only one proof was taken before the block was
destroyed. Designed to accompany the text for the theatrecraft section of the
New English Review, January 1922.

W21 **Winter Wood 1922**
Woodcut $5\frac{13}{16} \times 4\frac{1}{2}$
The Author
Gould Fletcher 21, Graham 5:7
V & A E4773–1960
Two editions: the first as an edition of 50 proofs on white wove or fine japon, the
second bound as plate 7 of *Places* by Paul Nash, William Heinemann Ltd, London 1922,
in an edition of 55 copies. Reproduced in *A History of Wood Engraving* by Douglas Percy
Bliss, Dent, London 1928. The cancelled block is in the collection of the Victoria and
Albert Museum, Accession No. E5195–1960.

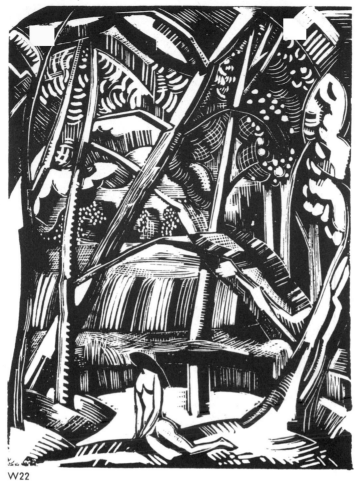

W22

W22 **Black Poplar Pond** 1922
Woodcut $6 \times 4\frac{1}{2}$
P. & D. Colnaghi Ltd
Gould Fletcher 22, Graham 5:2
V & A E4771–1960
Two editions: the first in an edition of 50 proofs on white wove or fine japon; the second bound as plate 2 of *Places* by Paul Nash, William Heinemann Ltd, London 1922, in an edition of 55 copies. Reproduced in *The Modern Woodcut* by Herbert Furst, John Lane Ltd, London 1924. The cancelled woodblock is in the collection of the Victoria and Albert Museum, Accession No. E5190–1960.

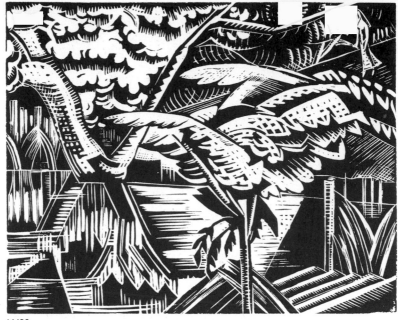

W23

W23 **Garden Pond 1922**
Woodcut $4\frac{1}{16} \times 5\frac{1}{16}$
P. & D. Colnaghi Ltd
Gould Fletcher 24, Graham 5:3
V & A E1456–1922
Two editions: the first as an edition of 50 proofs on white wove or fine japon; the
second bound as plate 3 of *Places* by Paul Nash, William Heinemann Ltd, London 1922,
in an edition of 55 copies. The cancelled woodblock is in the collection of the Victoria
and Albert Museum, Accession No. E5191–1960.

W24 **Meeting Place 1922**
Woodcut $4\frac{1}{2} \times 6$
The Author
Gould Fletcher 25, Graham 5:1
V & A E4770–1960
Two editions: the first as an edition of 50 proofs on white wove or fine japon; the
second bound as plate 1 of *Places* by Paul Nash, William Heinemann Ltd, London 1922,
in an edition of 55 copies. The cancelled woodblock is in the collection of the Victoria
and Albert Museum, Accession No. E5189–1960.

W25 **Dyke by the Road 1922**
Woodcut $4\frac{7}{8} \times 7\frac{1}{8}$
The Author
Gould Fletcher 26
V & A E4776–1960
Edition of 50 proofs on white wove paper, some numbered as from edition of 25 proofs
in error.

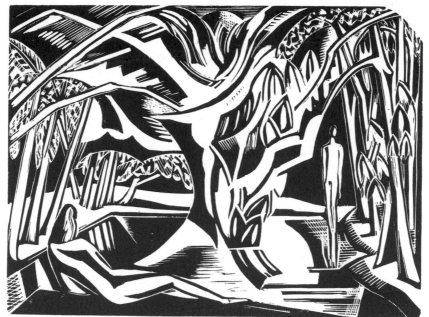

W24

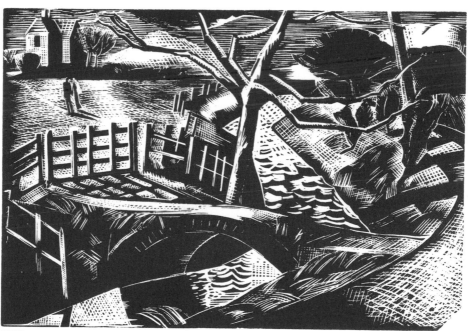

W25

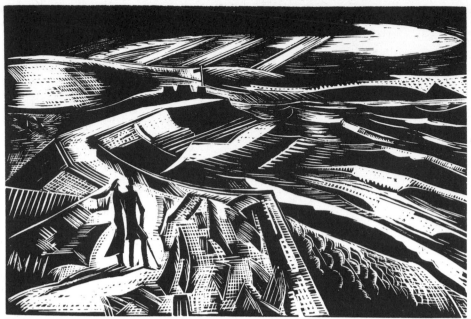

W27

W26 **Farewell 1922**
Woodcut $3\frac{13}{16} \times 3\frac{1}{16}$
Gould Fletcher 27, Graham 5:8
Edition of 55 proofs bound as the tailpiece to *Places* by Paul Nash, William Heinemann
Ltd, London 1922.

W27 **The Bay 1923**
Woodcut $4\frac{3}{4} \times 7$
P. & D. Colnaghi Ltd
Gould Fletcher 23
V & A E1462–1922, E4768–1960
Edition of 50 proofs on white wove paper.

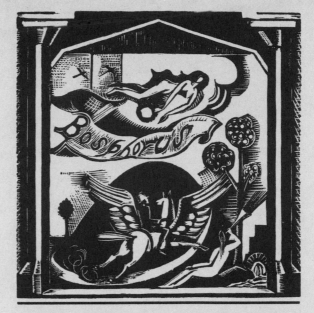

**MISTER BOSPHORUS
AND THE MUSES**
BY
FORD MADOX FORD
(FORD MADOX HUEFFER)
WITH DECORATIONS BY
PAUL NASH

DUCKWORTH & CO. LONDON

MISTER BOSPHORUS AND THE MUSES

10/6
NET

DUCKWORTH

W28

W28 **Parnassus 1923**
Woodcut 5 × 5
The Victoria and Albert Museum
Gould Fletcher 28, Graham 6:1
V & A E4173–1923
Cover design to *Mister Bosphorus and the Muses* by Ford Madox Ford (Ford Madox
Hueffer), Duckworth & Co., London 1923. Edition of 1,000 copies on blue-grey wove.

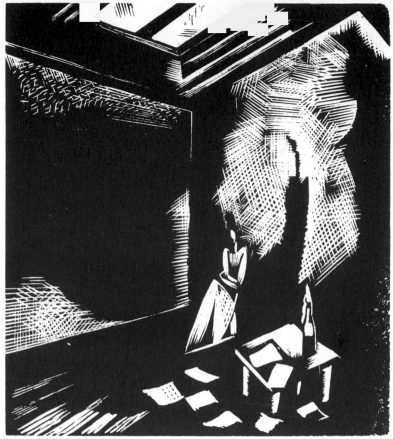

W29

W29 **Poor Northern Muse 1923**
Woodcut $4\frac{1}{4} \times 4$
P. & D. Colnaghi Ltd
Gould Fletcher 29, Graham 6:2
Two editions: the first signed and numbered in an edition of 15 proofs on white wove
paper; the second bound as the first illustration to *Mister Bosphorus and the Muses* by
Ford Madox Ford (Ford Madox Hueffer), Duckworth & Co., London 1923, in an edition
of 1,000 copies. The cancelled woodblock is in the collection of the Victoria and Albert
Museum, Accession No. E5197–1960.

W30 **Arthur in the Birken Hut 1923**
Woodcut $3\frac{1}{2} \times 3\frac{1}{2}$
Gould Fletcher 30, Graham 6:3
Third illustration to *Mister Bosphorus and the Muses* by Ford Madox Ford (Ford Madox
Hueffer), Duckworth & Co., London 1923, edition of 1,000 copies.

W31

W31 **Exit Northern Muse 1923**
Woodcut $3\frac{1}{2} \times 2\frac{5}{16}$
The Author
Gould Fletcher 31, Graham 6:4
Two editions: the first signed and numbered from an edition of 17 proofs on white wove
paper, the second bound as the fourth illustration to *Mister Bosphorus and the Muses* by
Ford Madox Ford (Ford Madox Hueffer) Duckworth & Co., London 1923, in an edition of
1,000 copies. Some proofs are inscribed "Exit the Char".

W32 **The Close-up 1923**
Woodcut $4 \times 4\frac{1}{16}$
Gould Fletcher 32, Graham 6:5
Fifth illustration to *Mister Bosphorus and the Muses* by Ford Madox Ford (Ford Madox
Hueffer), Duckworth & Co., London 1923, in an edition of 1,000 copies.

W33 **Decoration 1923**
Woodcut $2\frac{1}{4} \times 4\frac{9}{16}$
Gould Fletcher 33, Graham 6:6
Sixth illustration to *Mister Bosphorus and the Muses* by Ford Madox Ford (Ford Madox
Hueffer), Duckworth & Co., London 1923, in an edition of 1,000 copies.

W34 **Romantic Drama 1923**
Woodcut $4\frac{1}{16} \times 4\frac{1}{16}$
Gould Fletcher 34, Graham 6:7
Seventh illustration to *Mister Bosphorus and the Muses* by Ford Madox Ford (Ford Madox
Hueffer), Duckworth & Co., London 1923, in an edition of 1,000 copies.

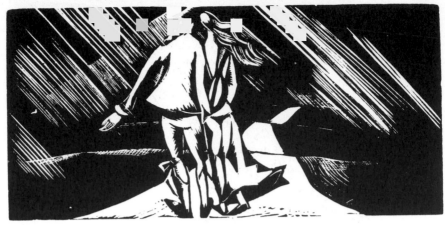

W35

W35 **Road over a Moor 1923**
Woodcut $2\frac{1}{4} \times 4\frac{5}{8}$
The Author
Gould Fletcher 35, Graham 6:8
Two editions: the first signed and numbered from an edition of 15 proofs on white
wove paper; the second bound as the eighth illustration to *Mister Bosphorus and the
Muses* by Ford Madox Ford (Ford Madox Hueffer), Duckworth & Co., London 1923,
in an edition of 1,000 copies.

W36 **Ga-Ga 1923**
Woodcut $4\frac{1}{2} \times 4\frac{1}{16}$
Gould Fletcher 36, Graham 6:9
Ninth illustration to *Mister Bosphorus and the Muses* by Ford Madox Ford (Ford Madox
Hueffer), Duckworth & Co., London 1923, in an edition of 1,000 copies.

W37 **Death of Bosphorus 1923**
Woodcut $5\frac{1}{16} \times 5\frac{1}{16}$
Gould Fletcher 37, Graham 6:10
Tenth illustration to *Mister Bosphorus and the Muses* by Ford Madox Ford (Ford Madox
Hueffer), Duckworth & Co., London 1923, in an edition of 1,000 copies.

W38 **Westminster Abbey 1960 Odd 1923**
Woodcut $5\frac{1}{16} \times 5\frac{1}{16}$
Gould Fletcher 38, Graham 6:11
Eleventh illustration to *Mister Bosphorus and the Muses* by Ford Madox Ford (Ford Madox
Hueffer), Duckworth & Co., London 1923, in an edition of 1,000 copies.

W39

W39 **Elysium 1923**
Woodcut $4\frac{1}{2} \times 4$
P. & D. Colnaghi Ltd
Gould Fletcher 19
Issued in an edition of 15 signed and numbered proofs on white wove.

W40 **Hanging Garden 1923**
Woodcut $6\frac{9}{16} \times 5\frac{1}{2}$
Gould Fletcher 40
Issued in an edition of 50 signed and numbered proofs on white wove paper. Some numbered as from edition of 25 in error.

Portrait of proud Paul.

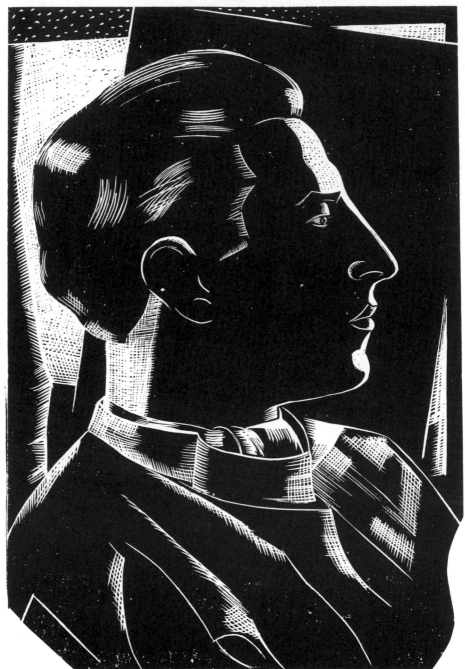

engraving on wood
proof - not final
rare state.

W41

 1922

W42

W41 **Portrait of Proud Paul 1922–1923**
Woodcut $7 \times 4\frac{3}{4}$
The Victoria and Albert Museum
Gould Fletcher 41
V & A E43–1968
Only two proofs taken, a working proof and the final state. The working proof is in the
collection of the Victoria and Albert Museum and the final state was presented to the
British Museum. This self-portrait was reproduced as the frontispiece to *Paul Nash* from
the "Contemporary British Artists" series by Albert Rutherston, Ernest Benn Ltd,
London 1923.

W42 **The Void 1924**
Woodcut $3\frac{3}{4} \times 3\frac{1}{4}$
P. & D. Colnaghi Ltd
Gould Fletcher 42, Graham 7
V & A E4756–1960
Two editions: the first in an edition of 12 signed and numbered proofs on white wove
or fine japon paper, the second bound as the first illustration to *Genesis*, Nonesuch Press,
London 1924, in an edition of 375 copies. The cancelled woodblock is in the collection
of the Victoria and Albert Museum, Accession No. E5178–1960.

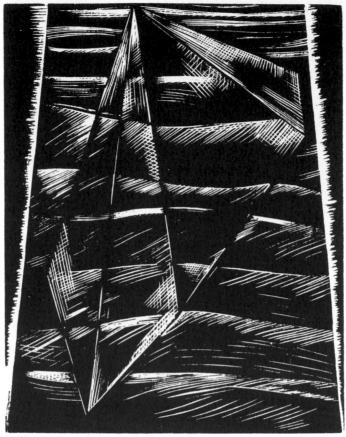

W43

W43 **The Face of the Waters 1924**
Woodcut $4\frac{1}{2} \times 3\frac{1}{2}$
P. & D. Colnaghi Ltd
Gould Fletcher 43, Graham 7
V & A E4757–1960
Two editions: the first signed and numbered from an edition of 12 proofs on fine japon
or white wove paper; the second bound as the second illustration to *Genesis*, Nonesuch
Press, London 1924, in an edition of 375 copies. The cancelled woodblock is in the
collection of the Victoria and Albert Museum, Accession No. E5179–1960.

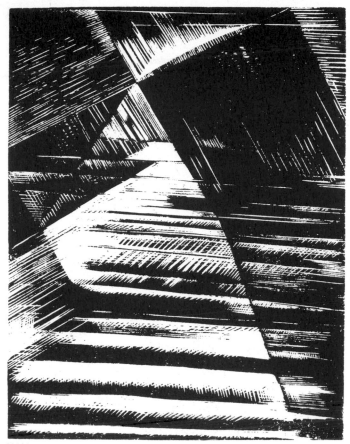

W44

W44 **The Division of the Light from the Darkness** 1924
Woodcut $4\frac{1}{2} \times 3\frac{1}{2}$
P. & D. Colnaghi Ltd
Gould Fletcher 44, Graham 7
V & A E4758–1960
Two editions: the first signed and numbered from an edition of 12 proofs on fine japon
or white wove paper; the second bound as the third illustration to *Genesis*, Nonesuch
Press, London 1924, in an edition of 375 copies. The cancelled woodblock is in the
collection of the Victoria and Albert Museum, Accession No. E5180–1960.

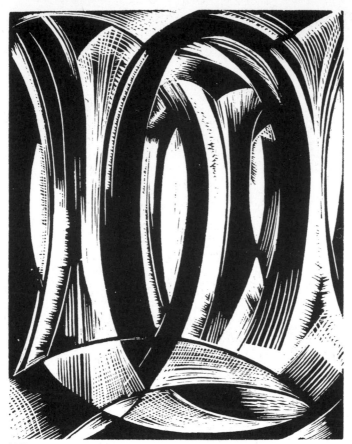

W45

W45 **Creation of the Firmament 1924**
Woodcut $4\frac{1}{2} \times 3\frac{1}{2}$
P. & D. Colnaghi Ltd
Gould Fletcher 45, Graham 7
V & A E4759–1960
Two editions: the first signed and numbered from an edition of 12 proofs on fine
japon or white wove paper; the second bound as the fourth illustration to *Genesis*,
Nonesuch Press, London 1924, in an edition of 375 copies. The cancelled woodblock
is in the collection of the Victoria and Albert Museum, Accession No. E5181–1960.

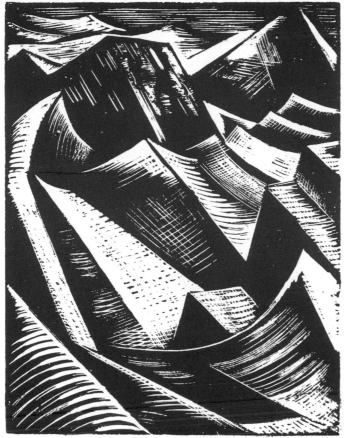

W46

W46 **The Dry Land Appearing** 1924
Woodcut $4\frac{1}{2} \times 3\frac{1}{2}$
P. & D. Colnaghi Ltd
Gould Fletcher 46, Graham 7
V & A E4760–1960
Two editions: the first in an edition of 12 signed and numbered proofs on fine japon
or white wove paper; the second bound as the fifth illustration to *Genesis*, Nonesuch
Press, London 1924, in an edition of 375 copies. The cancelled woodblock is in the
collection of the Victoria and Albert Museum, Accession No. 5182–1960.

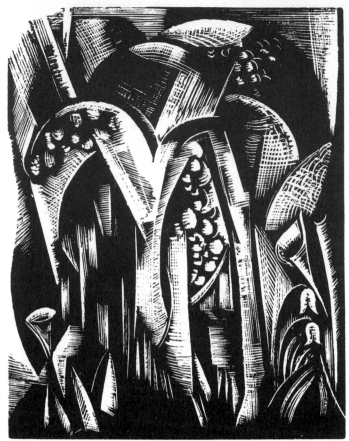

W47

W47 **Vegetation 1924**
Woodcut $4\frac{1}{2} \times 3\frac{1}{2}$
P. & D. Colnaghi Ltd
Gould Fletcher 47, Graham 7
V & A E4761–1960
Two editions: the first as 12 signed and numbered proofs on fine japon or white wove
paper; the second bound as the sixth illustration to *Genesis*, Nonesuch Press, London
1924, in an edition of 375 copies. The cancelled woodblock is in the collection of the
Victoria and Albert Museum, Accession No. E5183–1960.

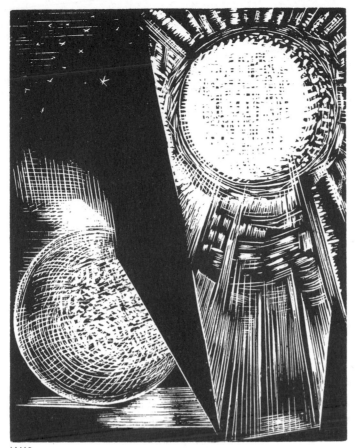

W48

W48 **The Sun and Moon 1924**
Woodcut $4\frac{1}{2} \times 3\frac{1}{2}$
P. & D. Colnaghi Ltd
Gould Fletcher 48, Graham 7
V & A E4762–1960
Two editions: the first as 12 signed and numbered proofs on fine japon or white wove paper; the second bound as the seventh illustration to *Genesis*, Nonesuch Press, London 1924, in an edition of 375 copies. The cancelled woodblock is in the collection of the Victoria and Albert Museum, Accession No. E5184–1960.

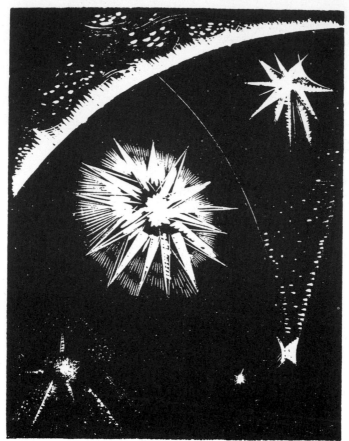

W49

W49 **The Stars Also** 1924
Woodcut $4\frac{1}{2} \times 3\frac{1}{2}$
P. & D. Colnaghi Ltd
Gould Fletcher 49, Graham 7
V & A E4763–1960
Two editions: the first as 12 signed and numbered proofs on fine japon or white wove
paper; the second bound as the eighth illustration to *Genesis*, Nonesuch Press, London
1924, in an edition of 375 copies. The cancelled woodblock is in the collection of the
Victoria and Albert Museum, Accession No. E5185–1960.

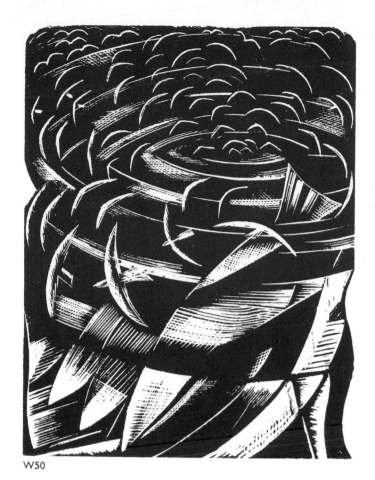

W50

W50 The Fish and Fowl 1924
Woodcut $4\frac{1}{2} \times 3\frac{1}{2}$
P. & D. Colnaghi Ltd
Gould Fletcher 50, Graham 7
V & A E4764–1960
Two editions: the first as 12 signed and numbered proofs on fine japon or white wove
paper; the second bound as the ninth illustration to *Genesis*, Nonesuch Press, London
1924, in an edition of 375 copies. The cancelled woodblock is in the collection of the
Victoria and Albert Museum, Accession No. E5186–1960.

W51

W51 **Cattle and Creeping Thing** 1924
Woodcut $4\frac{1}{2} \times 3\frac{1}{2}$
P. & D. Colnaghi Ltd
Gould Fletcher 51, Graham 7
V & A E4765–1960
Two editions: the first as 12 signed and numbered proofs on fine japon or white wove
paper; the second bound as the tenth illustration to *Genesis*, Nonesuch Press, London
1924, in an edition of 375 copies. The cancelled woodblock is in the collection of the
Victoria and Albert Museum, Accession No. E5187–1960.

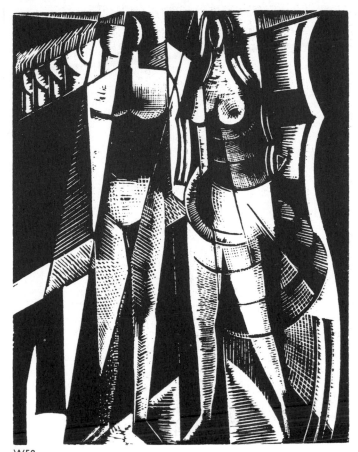

W52

W52 **Man and Woman 1924**
Woodcut $4\frac{1}{2} \times 3\frac{1}{2}$
P. & D. Colnaghi Ltd
Gould Fletcher 52, Graham 7
V & A E4766–1960
Two editions: the first as 12 signed and numbered proofs on fine japon or white wove
paper; the second bound as the eleventh illustration to *Genesis*, Nonesuch Press, London
1924, in an edition of 375 copies. The cancelled woodblock is in the collection of the
Victoria and Albert Museum, Accession No. E5188–1960.

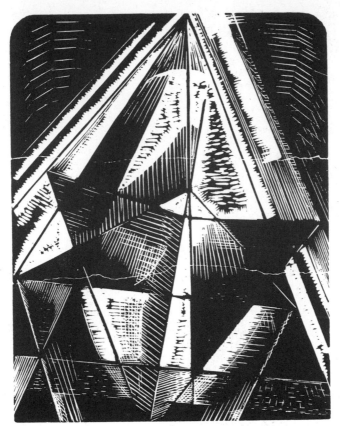

W53 W54

W53 **Contemplation 1924**
Woodcut $4\frac{1}{2} \times 3\frac{1}{2}$
P. & D. Colnaghi Ltd
Gould Fletcher 53, Graham 7
V & A E4767–1960
Two editions: the first in an edition of 5 signed and numbered proofs on white wove
paper; the second as the twelfth illustration to *Genesis*, Nonesuch Press, London 1924,
in an edition of 375 copies. There are also a number of proofs on white wove paper of
this print after the block had cracked in two places across the image.

W54 **Design for Invitation Card 1924**
Woodcut $3 \times 1\frac{1}{4}$
The Author
Gould Fletcher 54
Issued in an edition of 12 proofs on yellow japon or white wove paper. Designed for
the invitation card to the Exhibition of Nash's work at the Leicester galleries in May
1924.

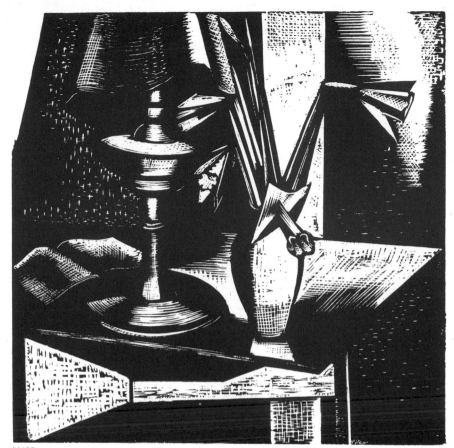

W55

W55 **Still Life No. 1 1924**
Woodcut $4\frac{1}{2} \times 4\frac{1}{2}$
The Author
Gould Fletcher 55
Issued in an edition of 50 proofs on white wove paper. The cancelled woodblock is in
the collection of the Victoria and Albert Museum, Accession No. E5198–1960.

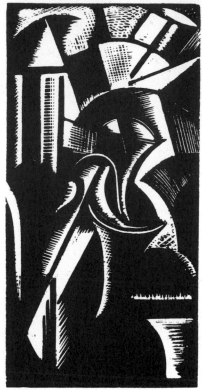

W56

W56 **Abstract No.1 1924**
Woodcut 4×2
The Author
Gould Fletcher 56, 57
Two editions: the first was issued as 12 proofs on white wove paper and the second
as 15 proofs on a white wove with a rust-red pattern. Gould Fletcher states that these
two editions were in fact impressions from different blocks, but there is no difference
in the image of both editions which would indicate that only one block was cut.

W57 **Cover Design 1925**
Woodcut $2\frac{1}{8} \times 1\frac{1}{2}$
Printed in repetition for the cover of *Wagner's Music Drama of the Ring* by L. Archier
Leroy, Noel Douglas, London 1925, edition of 1,500 copies.

W58 **Das Rheingold Scene I 1925**
Woodcut $3 \times 3\frac{5}{8}$
Gould Fletcher 59, Graham 9:1
Two editions: the first as 12 signed and numbered proofs on white japon; the second
bound as the first illustration to *Wagner's Music Drama of the Ring* by L. Archier Leroy,
Noel Douglas, London 1925, in an edition of 1,500 copies.

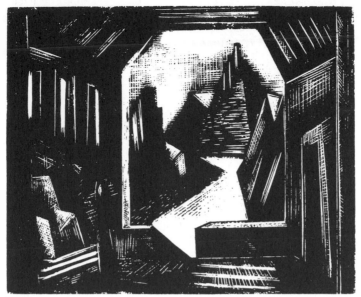

W58

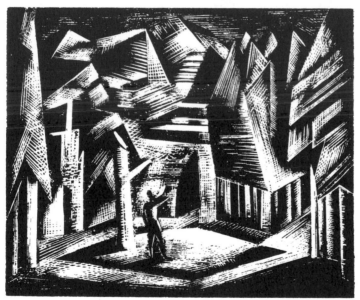

W59

W59 **Die Walkürie, Act III 1925**
Woodcut $3 \times 3\frac{5}{8}$
Gould Fletcher 60, Graham 9:2
Two editions: the first as 12 signed and numbered proofs on japon; the second
bound as the second illustration to *Wagner's Music Drama of the Ring* by L. Archier Leroy,
Noel Douglas, London 1925, in an edition of 1,500 copies.

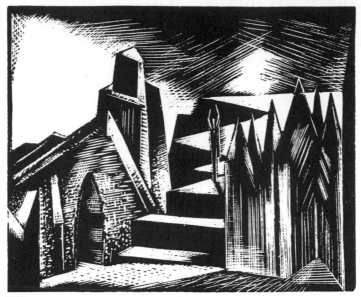

W60

W60 **Siegfried, Act II 1925**
Woodcut $3 \times 3\frac{5}{8}$
Gould Fletcher 61, Graham 9:3
Two editions: the first as 12 signed and numbered proofs on white japon; the second
bound as the third illustration to *Wagner's Music Drama of the Ring* by L. Archier Leroy,
Noel Douglas, London 1925, in an edition of 1,500 copies.

W61 **Götterdämmerung, Act III 1925**
Woodcut $3 \times 3\frac{5}{8}$
Gould Fletcher 62, Graham 9:4
Two editions: the first as 12 signed and numbered proofs on white japon; the second
bound as the fourth illustration to *Wagner's Music Drama of the Ring* by L. Archier Leroy,
Noel Douglas, London 1925, in an edition of 1,500 copies. Reproduced in *The Chapbook
Annual* 1925 and *The Theatre Arts Monthly*, January 1926.

W62 **Pond 1925**
Intaglio wood engraving $2\frac{5}{16} \times 4\frac{1}{8}$
P. & D. Colnaghi Ltd
Gould Fletcher 63
Edition of 15 proofs on white wove paper.

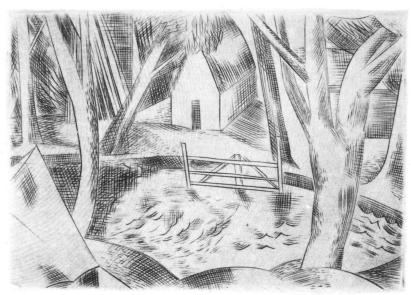

W62

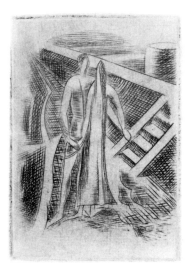

W63

W63 **Shore 1925**
Intaglio wood engraving $2\frac{9}{16} \times 1\frac{13}{16}$
Hamet Gallery Limited
Gould Fletcher 64
Edition of 25 proofs on white wove paper.

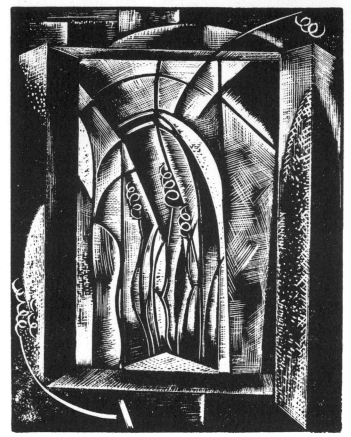

W64

W64 **Coronilla 1925**
Woodcut $4\frac{9}{16} \times 3\frac{9}{16}$
The Author
Gould Fletcher 65
V & A E4769–1960
Issued in an edition of 25 signed and numbered proofs on white wove paper.
Reproduced in *The Chapbook Annual* 1925.

W65 **Arches 1925**
Woodcut $5\frac{1}{2} \times 4$
Gould Fletcher 66
According to Gould Fletcher only one proof was taken. Reproduced in *The Chapbook Annual* 1925.

W66 **Leda 1925**
Woodcut $4\frac{3}{4} \times 3\frac{1}{2}$
Gould Fletcher 67
According to Gould Fletcher two editions of 25 proofs were printed. The first edition was lost in posting abroad, the second edition withdrawn and destroyed.

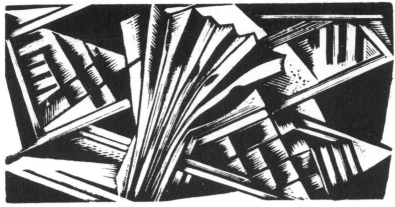

W67

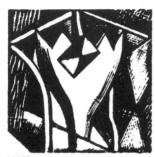

W68

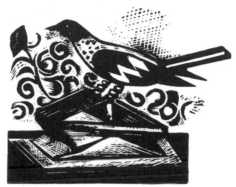

W69

W67 **Abstract Design for Menu Card 1925**
Woodcut $2\frac{1}{16} \times 4\frac{1}{16}$
The Author
Gould Fletcher 68
Printed in an edition of 12 on yellow japon. Engraved for the Menu of the dinner of the Double Crown Club, 17 February 1925.

W68 **Flower 1925**
Woodcut $1\frac{1}{2} \times 1\frac{1}{2}$
The Author
Gould Fletcher 69, Graham 10
Two editions: the first as 12 signed and numbered proofs on yellow japon; the second used in repetition for the cover to *Welchman's Hose* by Robert Graves, The Fleuron Ltd, London 1925. Reproduced in *Drawing and Design*, October 1926.

W69 **Bird 1925**
Woodcut $2 \times 2\frac{1}{2}$
The Author
Gould Fletcher 70, Graham 10
Two editions: the first as 15 signed and numbered proofs on white wove paper; the second as the title-page illustration to *Welchman's Hose* by Robert Graves, The Fleuron Ltd, London 1925, in an edition of 525 copies.

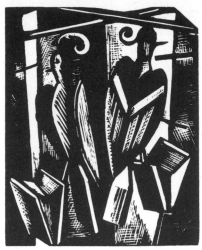

W71

W70 **Decoration (Ferns) 1925**
Woodcut 3×2
Gould Fletcher 71, Graham 10
Bound as an illustration to *Welchman's Hose* by Robert Graves, The Fleuron Ltd,
London 1925, in an edition of 525 copies.

W71 **Birds 1925**
Woodcut $2\frac{1}{2} \times 2$
The Author
Gould Fletcher 72, Graham 10
Two editions: the first as 25 signed and numbered proofs on yellow japon or white
wove paper; the second bound as an illustration to *Welchman's Hose* by Robert Graves,
The Fleuron Ltd, London 1925, in an edition of 525 copies.

W72 **Head of a Girl 1925**
Woodcut $1\frac{1}{2} \times 1\frac{1}{4}$
Gould Fletcher 73, Graham 10
Bound as an illustration to *Welchman's Hose* by Robert Graves, The Fleuron Ltd,
London 1925, in an edition of 525 copies. The cancelled woodblock is in the collection
of the Victoria and Albert Museum, Accession No. E5200–1960.

W73 **Decoration 1925**
Woodcut $1\frac{1}{2} \times 1\frac{1}{4}$
Gould Fletcher 74, Graham 10
Bound as an illustration to *Welchman's Hose* by Robert Graves, The Fleuron Ltd,
London 1925, in an edition of 525 copies.

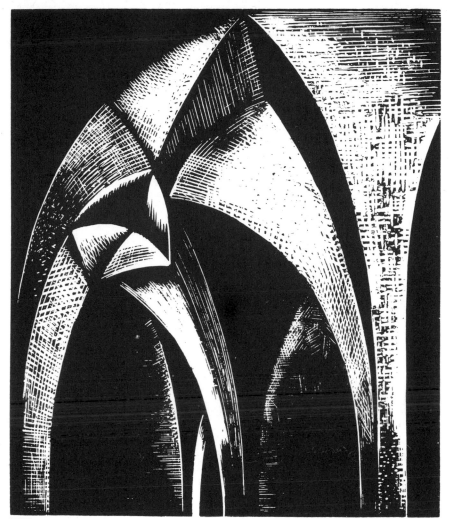

W74

W74 **Design of Arches 1926**
Woodcut $5\frac{1}{4} \times 4\frac{1}{2}$
P. & D. Colnaghi Ltd
Gould Fletcher 75
Issued in edition of 25 signed and numbered proofs on white wove paper. The
cancelled woodblock is in the collection of the Victoria and Albert Museum, Accession
No. E5201–1960. Reproduced in *A History of Wood-Engraving* by Douglas Percy Bliss,
Dent, London 1928, and in *Drawing and Design*, April 1928.

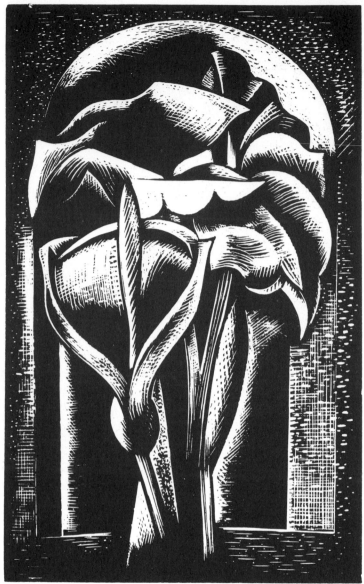

W75

Design of Flowers 1926
Woodcut $6 \times 3\frac{3}{4}$
P. & D. Colnaghi Ltd
Gould Fletcher 76
Issued as an edition of 25 signed and numbered proofs on white wove paper. The cancelled woodblock is in the collection of the Victoria and Albert Museum, Accession No. E5202–1960.

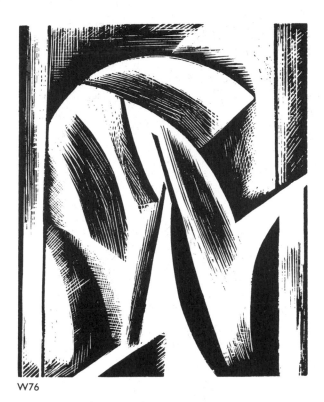

W76

W76 **Abstract (No. 2) 1926**
Woodcut $3\frac{5}{8} \times 3$
The Author
Gould Fletcher 77
Issued as an edition of 25 signed and numbered proofs on white wove paper. The
cancelled woodblock is in the collection of the Victoria and Albert Museum, Accession
No. E5203–1960.

W77 **Cover Design 1926**
Woodcut $1\frac{1}{8} \times 2\frac{15}{16}$
Gould Fletcher 78
Design made for the Curwen Press and used in repetition on the covers of *The
Woodcut: An Annual*, No. 1, The Fleuron Ltd, London 1927.

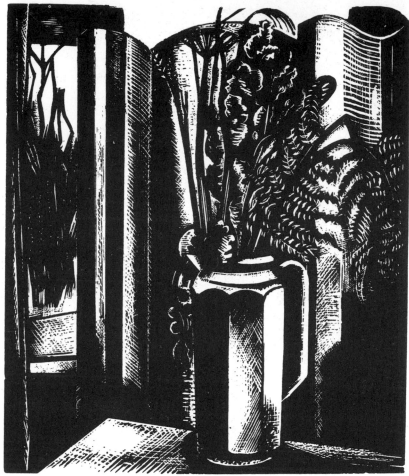

W78

W78 **Still Life, No. 2 1927**
Woodcut $5\frac{1}{4} \times 4\frac{9}{16}$
P. & D. Colnaghi Ltd
Gould Fletcher 79
Issued in an edition of 50 signed and numbered proofs on white wove paper. The
cancelled woodblock is in the collection of the Victoria and Albert Museum, Accession
No. E5204–1960.

W79 **Bouquet 1927**
Woodcut $4\frac{3}{16} \times 3\frac{3}{4}$
The Author
Gould Fletcher 80
Issued in an edition of 50 signed and numbered proofs on white wove paper. Reproduced
in *The Woodcut: An Annual*, No. 2, The Fleuron Ltd, London 1928.

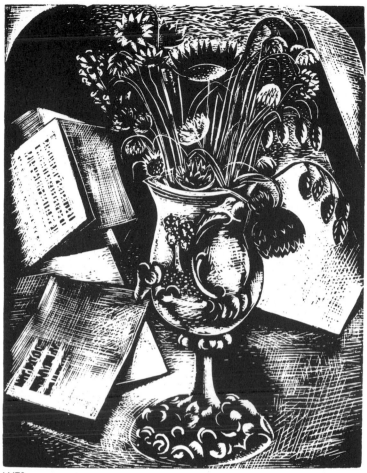

W79

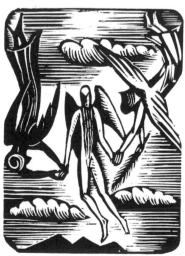

W80 **Angels 1927**
Woodcut $2\frac{13}{16} \times 2$
The Author
Gould Fletcher 81, Graham 15
Two editions: the first as 12 proofs on white
japon; the second on fine japon trimmed to
the blockmark and mounted as the title page
to *Abd-er-Rhaman in Paradise* by Jules Tellier,
Golden Cockerel Press, 1928, in an edition of
400 copies.

W80

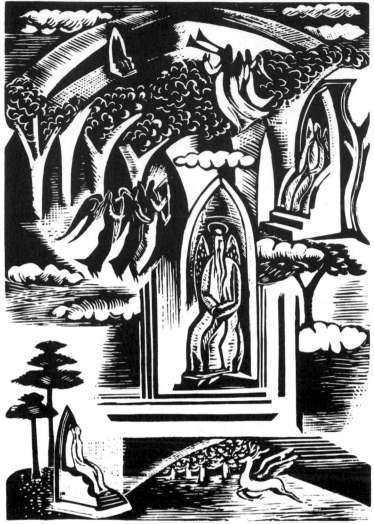

W81

W81 **Heaven 1927**
Woodcut $7\frac{7}{16} \times 3\frac{13}{16}$
The Author
Gould Fletcher 82, Graham 15
Two editions: the first as **12** proofs on white japon; the second on fine japon trimmed to the blockmark and mounted as the first illustration to *Abd-er-Rhaman in Paradise* by Jules Tellier, Golden Cockerel Press, 1928, in an edition of **400** copies.

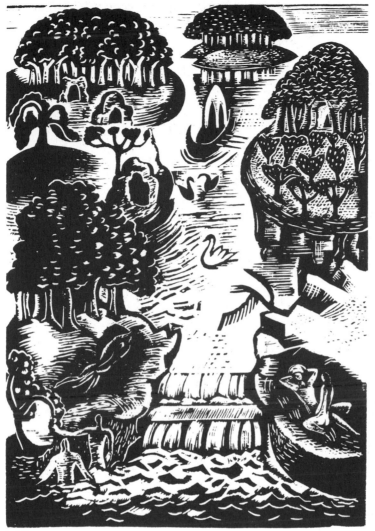

W82

W82 **Paradise 1927**
Woodcut $5\frac{1}{2} \times 3\frac{3}{4}$
The Author
Gould Fletcher 83, Graham 15
Two editions: the first as 12 proofs on white japon; the second on fine japon and trimmed
to the blockmark mounted as the second illustration to *Abd-er-Rhaman in Paradise* by
Jules Tellier, Golden Cockerel Press, 1928, in an edition of 400 copies.

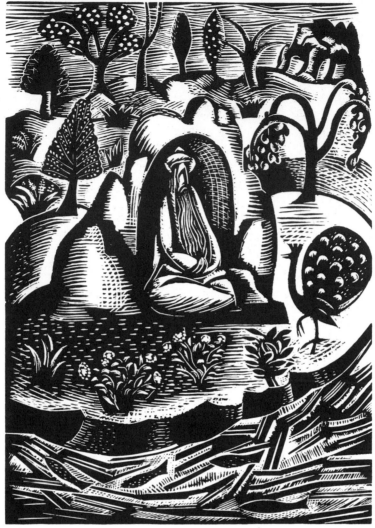

W83

W83 **Boredom 1927**
Woodcut $5\frac{3}{8} \times 5\frac{3}{4}$
The Author
Gould Fletcher 84, Graham 15
Two editions: the first as 12 proofs on white japon; the second on fine japon, trimmed
to the blockmark and mounted as the third illustration to *Abd-er-Rhaman in Paradise* by
Jules Tellier, The Golden Cockerel Press, 1928, in an edition of 400 copies.

W84

W85

W86

W84 **Design I 1929**
Woodcut $4\frac{1}{16} \times 1\frac{1}{2}$
The Author
Graham 16
Two editions: the first as 50 proofs on white wove or fine japon paper; the second bound as the first illustration to *A Song about Tsar Ivan Vasilyevitch* · · · by Mikhail Lermontov, Aquila Press, London 1929, in an edition of 750 copies on Maillol hand-made paper.

W85 **Design 2 1929**
Woodcut $1\frac{9}{16} \times 4$
The Author
Graham 16
Two editions: the first as 50 proofs on white wove or fine japon paper; the second as the second illustration to *A Song about Tsar Ivan Vasilyevitch* · · · by Mikhail Lermontov, Aquila Press, London 1929, in an edition of 750 copies on Maillol hand-made paper.

W86 **Design 3 1929**
Woodcut $1\frac{1}{16} \times 4$
The Author
Graham 16
Two editions: the first as 50 proofs on white wove or fine japon paper; the second as the third illustration to *A Song about Tsar Ivan Vasilyevitch* · · · by Mikhail Lermontov, Aquila Press, London 1929, in an edition of 750 copies on Maillol hand-made paper.

FINIS.

W87

W88

W87 **Design 4 1929**
Woodcut $4 \times 1\frac{1}{16}$
The Author
Graham 16
Two editions: the first as 50 proofs on white wove or fine japon paper; the second as the
fourth illustration to *A Song about Tsar Ivan Vasilyevitch* · · · by Mikhail Lermontov, Aquila
Press, London 1929, in an edition of 750 copies on Maillol hand-made paper.

W88 **Coronilla No. 2 1925–1930**
Woodcut $4\frac{1}{2} \times 3\frac{1}{2}$
P. & D. Colnaghi Ltd
Issued as an edition of 25 signed and numbered proofs on white wove paper.

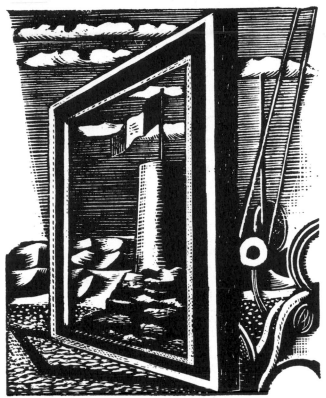

W89

W89 **Bookplate for Samuel Courtauld** *c.1930*
Woodcut $4 \times 3\frac{3}{16}$
The Author
V & A E728–1935
Two editions: approximately 5 proofs on fine japon and a large number on adhesive
white wove with SAMUEL COURTAULD added across the base in letterpress.

Appendix I

The lithographs of the First World War as they were originally exhibited
[See Nos. 8, 25, 26, 32, 43, 47, 52]

THE LEICESTER GALLERIES (1918)
Leicester Square, London WC1
'VOID OF WAR'
AN EXHIBITION OF PICTURES
BY LIEUT. PAUL NASH
(An official artist on the Western Front)
With a prefatory note by
ARNOLD BENNETT

1 **Meadow with Copse. Tower Hamlets District 1918**
Watercolour 10″ × 14″
(G. H. Nevill Esq)

2 **Ruined Country. Old Battlefield, Vimy 1918**
Watercolour, pen and chalk 10″ × 15¼″
(The Imperial War Museum)

3 **Shell Bursting (Passchendaele) 1918**
Watercolour, pen and chalk
(The late Arnold Bennett)

4 **Landscape, Year of Our Lord 1917**
Watercolour and chalk 10″ × 14″ (Plate 15)
(National Gallery of Canada)

5 **Pools (called also Crater Pools) 1918**
Watercolour, pen and chalk
(Sir Osbert Sitwell)

6 **Down from the Line 1918**
Chalk 10¼″ × 14¼″
(The Imperial War Museum)

7 **Passchendaele 1918**
Oil on canvas

8 **Design for Poster for Exhibition**
Lithograph

9 **Broken Trees, Wytschaete 1918**
Monochrome in wash, pen and chalk on brown paper
(Mrs Paul Nash)

10 **Obstacle 1918**
(Mrs C. R. W. Nevinson)

11 **Caterpillar Crater 1918**
Watercolour, pen and chalk
(The late James Baird)

12 **Vimy Ridge 1918**
Watercolour, pen and chalk
(The late John Drinkwater)

13 **Graveyard in a Ruined Orchard near Vimy 1918**
Pen and wash 9″ × 11″
(National Gallery of Canada)

14 **Crater 1918**
Watercolour, pen and chalk
(The late Sir Michael Sadler)

15 **Existence 1918**
Chalk and watercolour 19″ × 12¾″
(The Imperial War Museum)

16 **Indians in Belgium 1918**
Watercolour, pen and chalk 13″ × 19¼″
(The Imperial War Museum)

17 **Dumbarton Lakes 1918**
Watercolour, pen and chalk 10″ × 14″
(National Gallery of Canada)

18 **Over Arras 1918**
Watercolour, pen and chalk
(Ernest Gye, Esq)

19 **Air Fight over Wytschaete 1918**
Watercolour, pen and chalk 10″ × 14″
(G. H. Nevill, Esq)

20 **Sketch of the German Front-line, Gheluvelt 1918,** Chalk 10″ × 14″
(Imperial War Museum)

21 **Lorries 1918**
Pen and wash drawing
(Mrs Paul Nash)

22 **Wytschaete Woods 1918**
Watercolour, pen and chalk

23 **Landscape, Hill 60 1918**
Watercolour, pen and chalk 10″ × 14⅛″
(Manchester Art Gallery, Rutherston Loan Collection)

24 **Company Headquarters 1918**
Pen and wash drawing

25 **Shell Bursting 1918**
Lithograph

26 **Rain 1918**
Lithograph

27 **Night in the Ypres Salient 1918**
Oil on canvas 28″ × 36″
(The Imperial War Museum)

28 **Stand To 1918**
Oil on canvas

29 **We Are Making a New World 1918**
Oil on canvas 28″ × 36″
(The Imperial War Museum)

30 **Very Lights 1918**
Watercolour, pen and chalk 9¼″ × 11″
(Mrs Alfred Leete)

31 **Desolation 1918**
(The late P. G. Konody)

32 **German Double Pill-box 1918**
Lithograph

33 **In the Tunnels** 1918
Pen, wash and chalk
(The late John Drinkwater)

34 **Dawn. Sanctuary Wood from Stirling Castle** 1918
Watercolour and chalk $10'' \times 14\frac{1}{2}''$
(The Blackpool Art Gallery)

35 **Noon. Shelling the Duckboards** 1918
Watercolour, pen and chalk
(The late James Baird)

36 **Sunset. Ruin of the Hospice, Wytschaete** 1918
Chalk $10'' \times 14''$
(The Imperial War Museum)

37 **Nightfall. Zillebecke District** 1918
Pen and chalk on brown paper $10'' \times 14''$
(The Imperial War Museum)

38 **Sunrise. Inverness Copse** 1918
Chalk on brown paper $9\frac{3}{4}'' \times 13\frac{3}{4}''$
(The Imperial War Museum)

39 **A Farm. Wytschaete** 1918
(Maresco Pearce Esq)

40 **Monument to the Canadians Fallen on Vimy Ridge** 1918
Watercolour $11\frac{1}{4}'' \times 14\frac{7}{8}''$
(National Gallery of Canada)

41 **Contract. Inland Water-transport** 1918
Pen and wash drawing

42 **Hill 60** 1918
Watercolour, pen and chalk
(The late Samuel Courtauld)

43 **Mine Crater, Hill 60** 1918
Lithograph $14'' \times 18''$
(The Imperial War Museum)

44 **Eruption** 1918
Monochrome and watercolour wash on brown paper
(Mrs Paul Nash)

45 **Mud Heaps after Shelling (H.E.)** 1918
Monochrome and watercolour on brown paper
(Sir Edward Marsh, K.C.V.O.)

46 **Mont St Eloi** 1918
Pen and chalk $11\frac{1}{2}'' \times 15\frac{1}{2}''$
(The Imperial War Museum)

47 **Rain. Lake Zillebecke** 1918
Lithograph $10'' \times 14\frac{1}{2}''$
(The Imperial War Museum)

48 **The Menin Road** 1918
Watercolour, pen and chalk

49 **Tortured Earth** 1918
Watercolour, pen and chalk

50 **The Field of Passchendaele** 1918
Watercolour, pen and chalk $9\frac{3}{4}'' \times 13\frac{5}{8}''$
(Manchester City Art Gallery, Rutherston Loan Collection)

51 **Chinese Working in a Quarry** 1918
Watercolour, pen and chalk $10\frac{3}{4}'' \times 14''$
(The Imperial War Museum)

52 **Marching at Night** 1918
Lithograph

53 **Night Bombardment** 1918
Watercolour, pen and chalk

54 **Void** 1918
Oil on canvas $28'' \times 36''$
(National Gallery of Canada)

55 **Lake Zillebecke, Nightfall** 1918
Watercolour, pen and chalk
(Peter Harris Esq)

56 **Tower Hamlets**

Appendix II

Transcript from catalogue of exhibition of wood engravings at Redfern Gallery 1928 showing editions as stated in 1928

THE REDFERN GALLERY (1928)
Old Bond Street, London W1
ENGRAVINGS ON WOOD (1919–1928)
BY PAUL NASH

1 **Diseuse** Edition Nil
2 **Tree Group** A few proofs
3 **Elms** Edition Nil (2 states)
4 **Snow** Edition Nil
5 **Sea Wall** A few proofs
6 **Lake in a Wood** Edition 25
7 **Promenade** Edition 25
8 **Winter** Edition 25
9 **Paths into the Wood** Edition 50
10 **Winter Wood** Edition 50
11 **Black Poplar Pond** Edition 50
12 **Garden Pond** Edition 25
13 **Meeting Place** Edition 25
14 **Dyke by the Road** Edition 50
15 **The Bay** Edition 50
16 **Still Life (No. I)** Edition 50
17 **Hanging Garden** Edition 50
18 **Coronilla** Edition 25
19 **Leda** Edition 25
20 **Pond (Intaglio)** Edition 15
21 **Shore (Intaglio)** Edition 15
22 **Abstract (No. I)** Edition 15
23 **Design of Arches** Edition 25
24 **Design of Flowers** Edition 25
25 **Abstract (No. 2)** Edition 25
26 **Still Life (No. 2)** Edition 50
27 **Bouquet** Edition 50

Five designs engraved for *Cotswold Characters*, by John Drinkwater (Yale Press, USA, 1921)

28 **Thesiger Crowne** Edition 9
29 **Simon Rodd** Edition 9
30 **Rufus Clay** Edition 9
31 **Pony the Footballer** Edition 9
32 **Joe Pintifer** Edition 9

Three designs from the set engraved for *Mr Bosphorus and the Muses*, by Ford Madox Ford (Duckworth, 1923)

33 **Northern Muse** Edition 15
34 **Road over a Moor** Edition 17
35 **Exit the Char** Edition 17

Twelve designs engraved for the first *Book of Genesis*, printed with the text (Nonesuch Press, 1924)

36 **Void** Edition 4
37 **Face of the Waters** Edition 12
38 **Division of Light and Darkness** Edition 12
39 **Creation of the Firmament** Edition 12
40 **Dry Land Appearing** Edition 12
41 **Vegetation** Edition 12
42 **Sun and Moon** Edition 12
43 **The Stars Also** Edition 12
44 **Fish and Fowl** Edition 12
45 **Cattle and Creeping Things** Edition 12
46 **Man and Woman** Edition 12
47 **Contemplation** Edition 4

Four designs engraved for *Wagner's Music Drama of the Ring*, by L. Archier Leroy (Noel Douglas, 1925)

48 **Das Rheingold** Edition 12
49 **Die Walkyrie** Edition 12
50 **Siegfried** Edition 12
51 **Götterdämmerung** Edition 12

Three of the five designs engraved for *Welshman's Hose*, by Robert Graves (The Fleuron, 1926)

52 **Bird** Edition 15
53 **Birds** Edition 25
54 **Flower** Edition 12
55 **Design** Edition 12
56 **Abstract Design** Edition 12

Four designs engraved for *Ab-er-Rhaman in Paradise*, by Jules Tellier. Translated by Brian Rhys (Golden Cockerel Press, 1928)

57 **Heaven** Edition 12
58 **Paradise** Edition 12
59 **Boredom** Edition 12
60 **The Two Angels** Edition 12
61 **Forest (Intaglio)** Edition 15